Incorporating Culture

Solen Roth

Incorporating Culture
How Indigenous People Are Reshaping the Northwest Coast Art Industry

UBCPress · Vancouver · Toronto

27 26 25 24 23 22 21 20 19 18 5 4 3 2 1

Printed in Canada on FSC-certified ancient-forest-free paper (100% post-consumer recycled) that is processed chlorine- and acid-free.

Library and Archives Canada Cataloguing in Publication Data

Roth, Solen, author
 Incorporating culture : how indigenous people are reshaping the Northwest Coast art industry / Solen Roth.

Includes bibliographical references and index.
Issued in print and electronic formats.
ISBN 978-0-7748-3738-5 (hardcover). – ISBN 978-0-7748-3739-2 (pbk.). –
ISBN 978-0-7748-3740-8 (PDF). – ISBN 978-0-7748-3741-5 (EPUB). –
ISBN 978-0-7748-3742-2 (Kindle)

 1. Indian art -- Economic aspects – Northwest Coast of North America.
2. Indian artists – Northwest Coast of North America – Economic conditions.
3. Commodification – Northwest Coast of North America. I. Title.

E78.N78R68 2018 704.03'9707111 C2018-902651-0
 C2018-902652-9

Canadä

UBC Press gratefully acknowledges the financial support for our publishing program of the Government of Canada (through the Canada Book Fund), the Canada Council for the Arts, and the British Columbia Arts Council.

This book has been published with the help of a grant from the Canadian Federation for the Humanities and Social Sciences, through the Awards to Scholarly Publications Program, using funds provided by the Social Sciences and Humanities Research Council of Canada, and with the help of the University of British Columbia through the K.D. Srivastava Fund.

Printed and bound in Canada by Friesens
Set in Myriad and Garamond by Apex CoVantage, LLC
Copy editor: Sarah Wight
Proofreader: Caitlin Gordon-Walker
Cover designer: George Kirkpatrick

UBC Press
The University of British Columbia
2029 West Mall
Vancouver, BC V6T 1Z2
www.ubcpress.ca

To my parents, with love and gratitude